INSTANT WALL ART:
VINTAGE MAP PRINTS

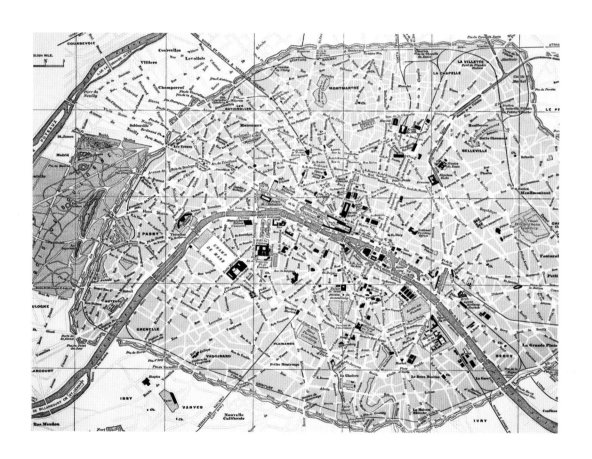

45 READY-TO-FRAME ILLUSTRATIONS
FOR YOUR HOME DÉCOR

Adams Media

New York London Toronto Sydney New Delhi

Adams Media

An Imprint of Simon & Schuster, Inc.

57 Littlefield Street

Avon, Massachusetts 02322

First Adams Media trade paperback edition DECEMBER 2017

ADAMS MEDIA and colophon are trademarks of Simon and Schuster.

For information about special discounts for bulk purchases, please contacta Simon & Schuster Special Sales at 1-866-506-1949 or business@simonandschuster.com.

The Simon & Schuster Speakers Bureau can bring authors to your live event. For more information or to book an event contact the Simon & Schuster Speakers Bureau at 1-866-248-3049 or visit our website at www.simonspeakers.com.

Interior design by Sylvia McArdle

Manufactured in the United States of America

10 9 8 7 6 5 4 3 2 1

ISBN 978-1-5072-0589-1

INTRODUCTION

Today, beautifully colored vintage maps are showing up everywhere you look—from popular design magazines and websites to the walls of your friends' living rooms and kitchens. And now, instead of having to choose between one or two expensive prints, you can choose from the forty-five beautiful illustrations found within the pages of *Instant Wall Art: Vintage Map Prints* to personalize your own walls!

From maps of the stars to some of the world's biggest cities, these prints span a variety of locations and time periods with muted colors and fine details that capture the beauty of the land, sea, and sky. Now, with images ranging from the streets of New York City to the London Underground to a view of the North Pole, you're sure to find something in this book that speaks to your design aesthetic. These map prints measure 8" × 10" and will fit in a standard mat and frame once removed from the book at the perforated edge. So choose the prints you love, hang them on your walls, and enjoy their elegance in your own home year round!

THE PRINTS

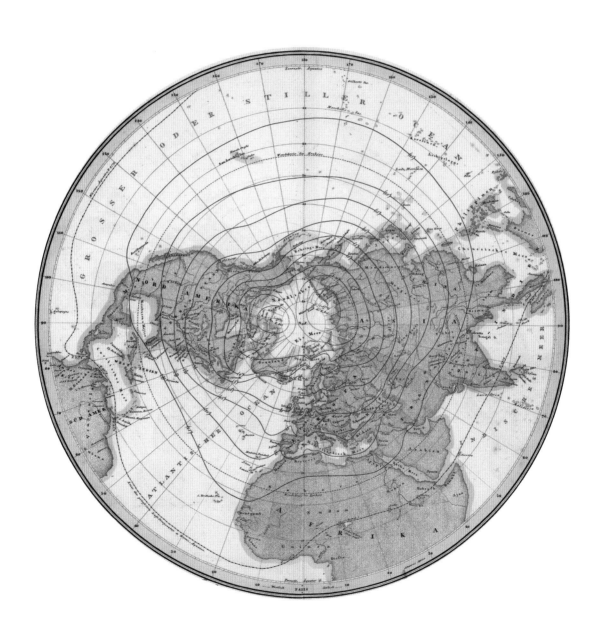

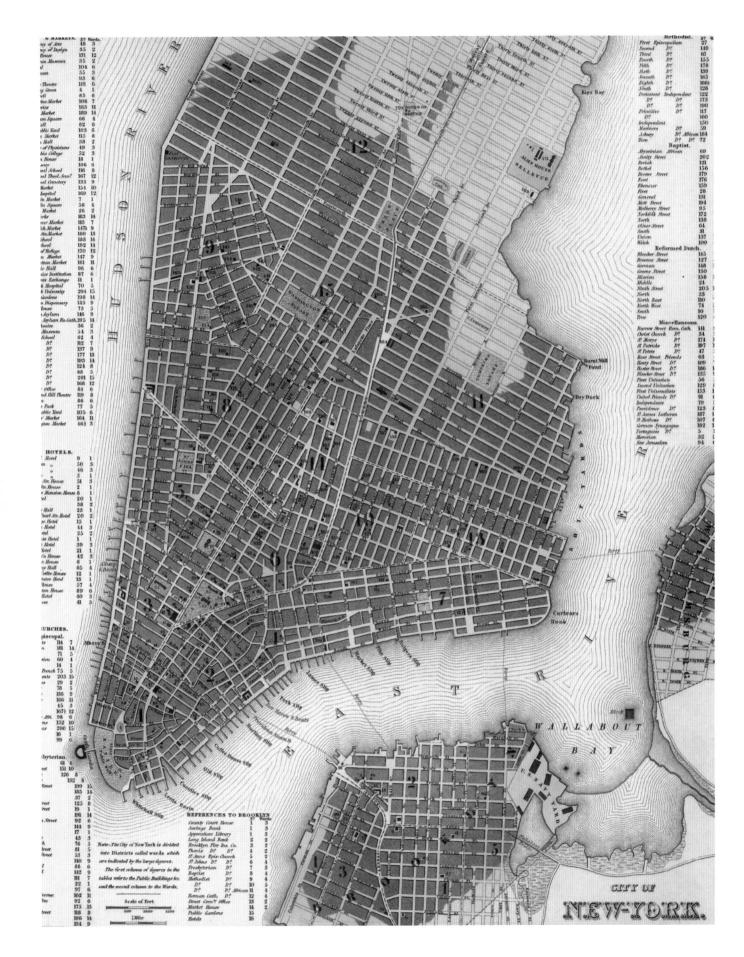

CITY OF
NEW-YORK.

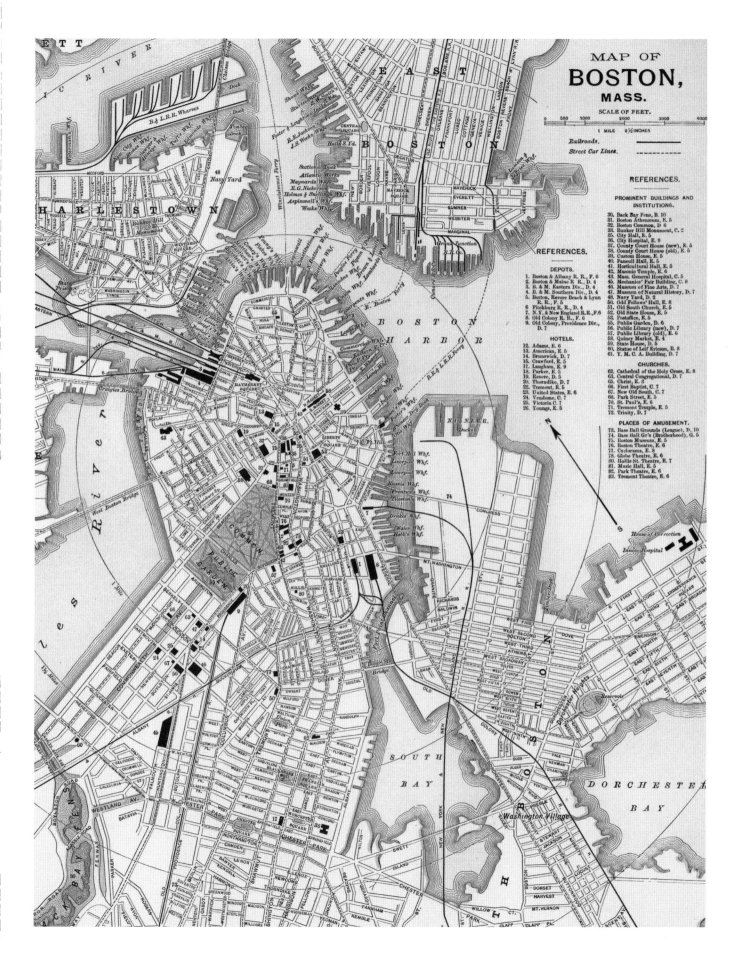

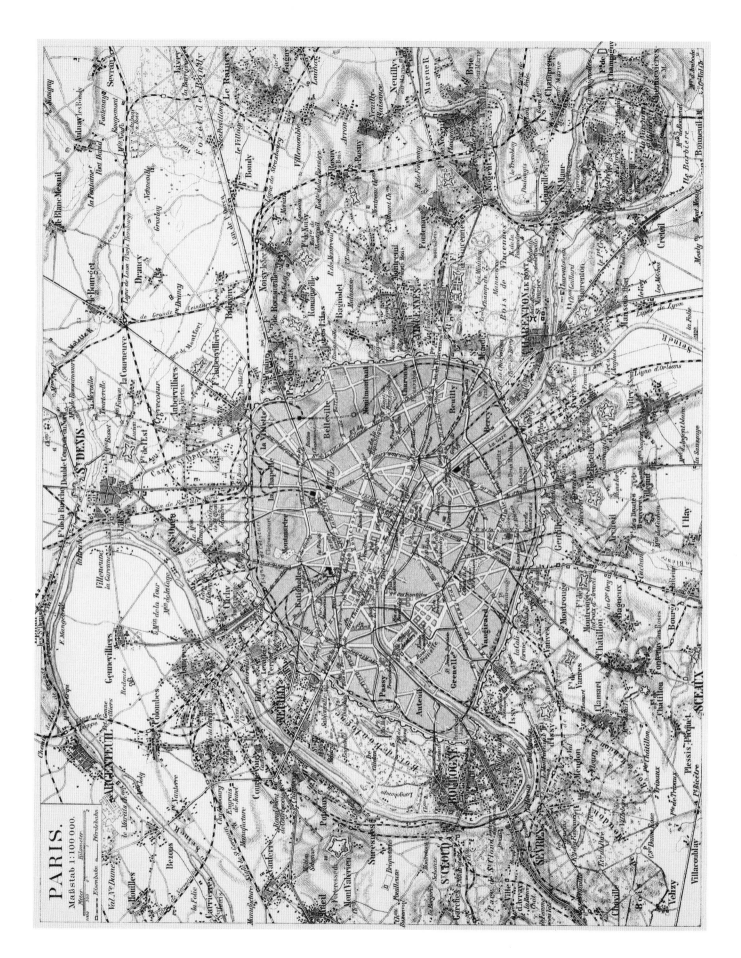

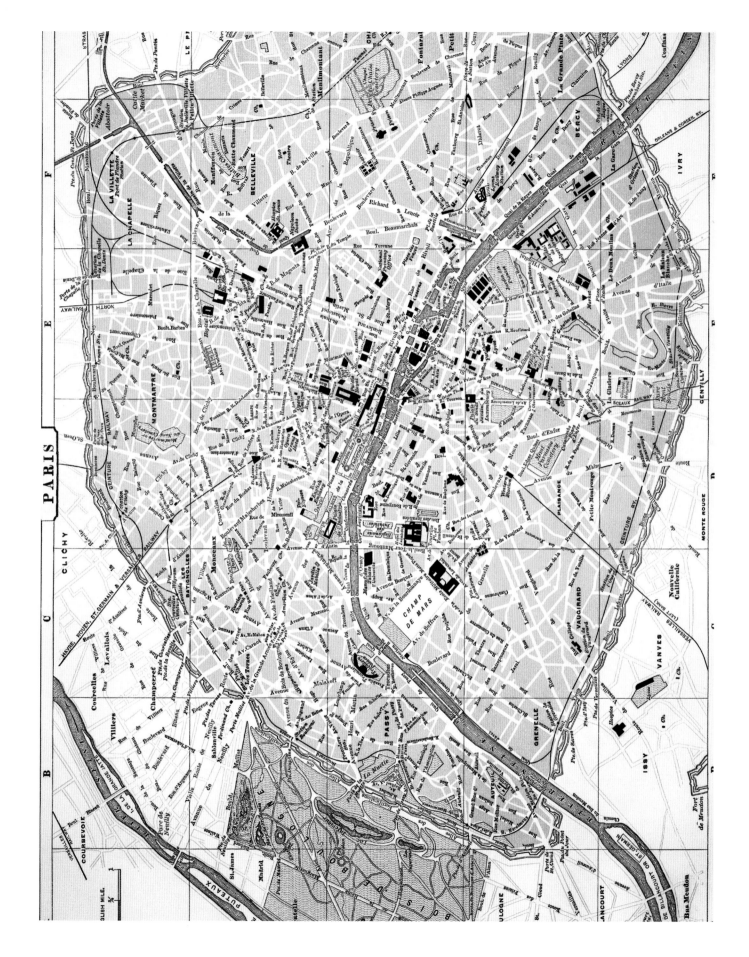

PARIS

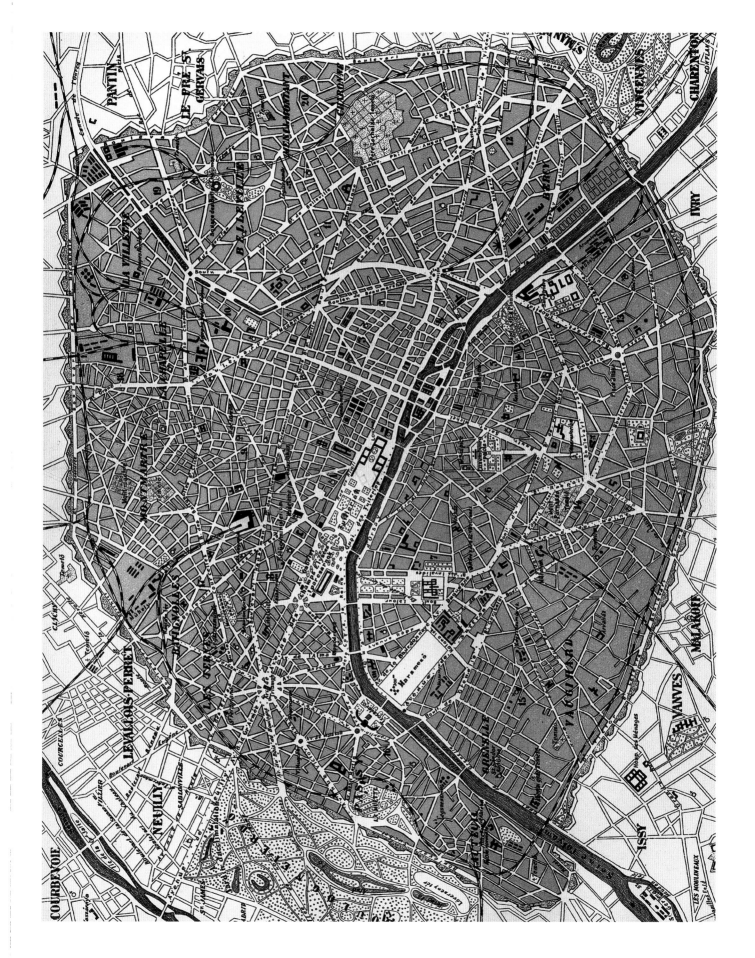

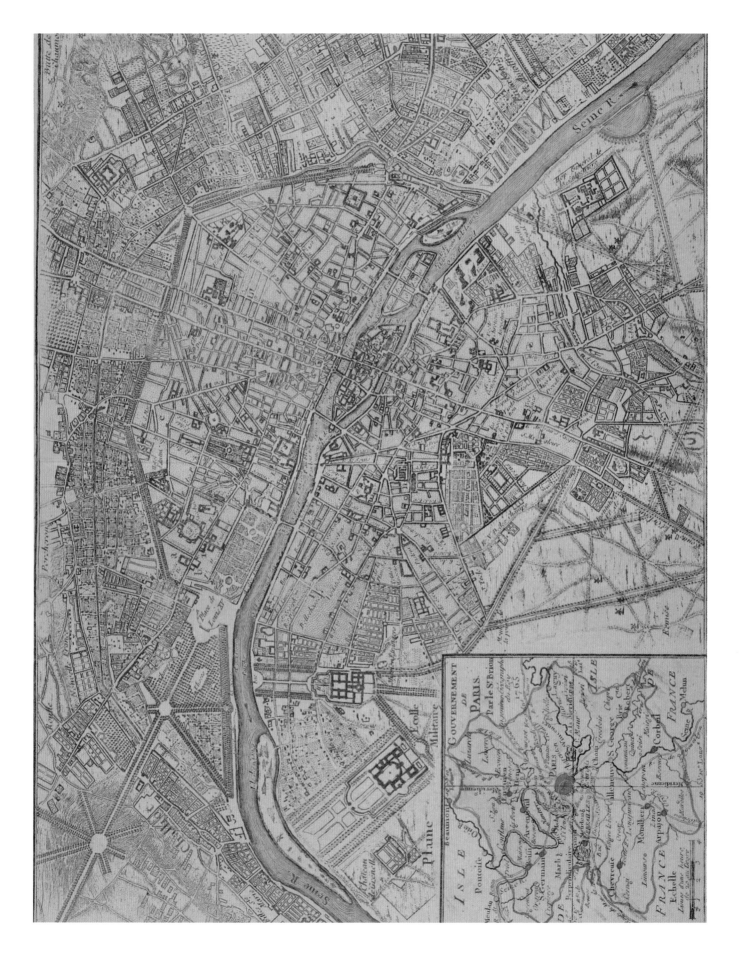

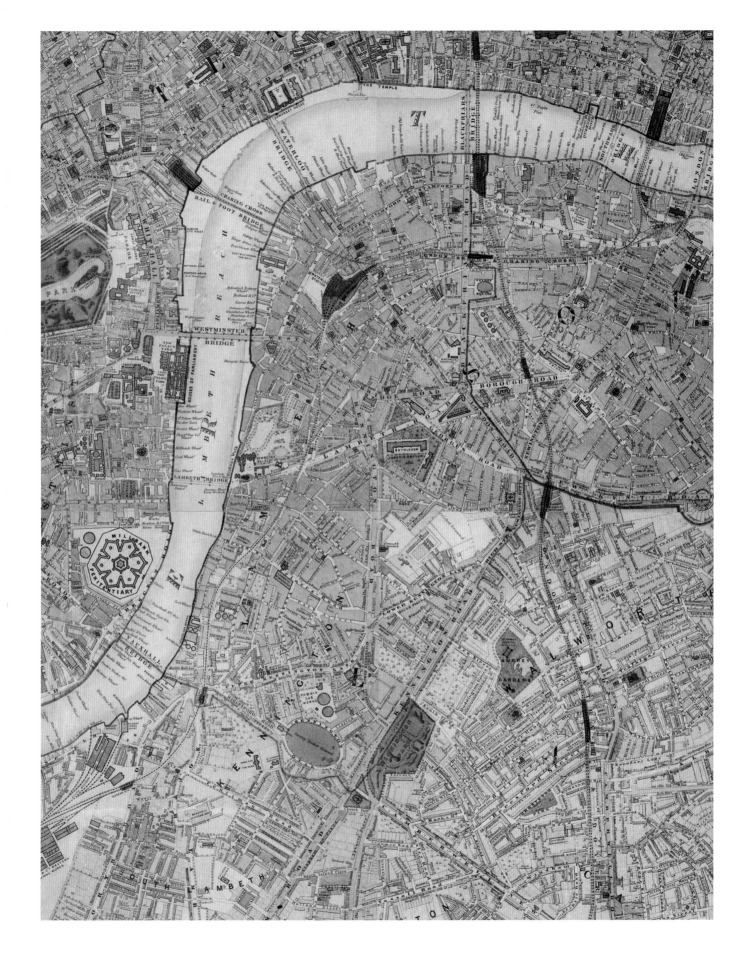

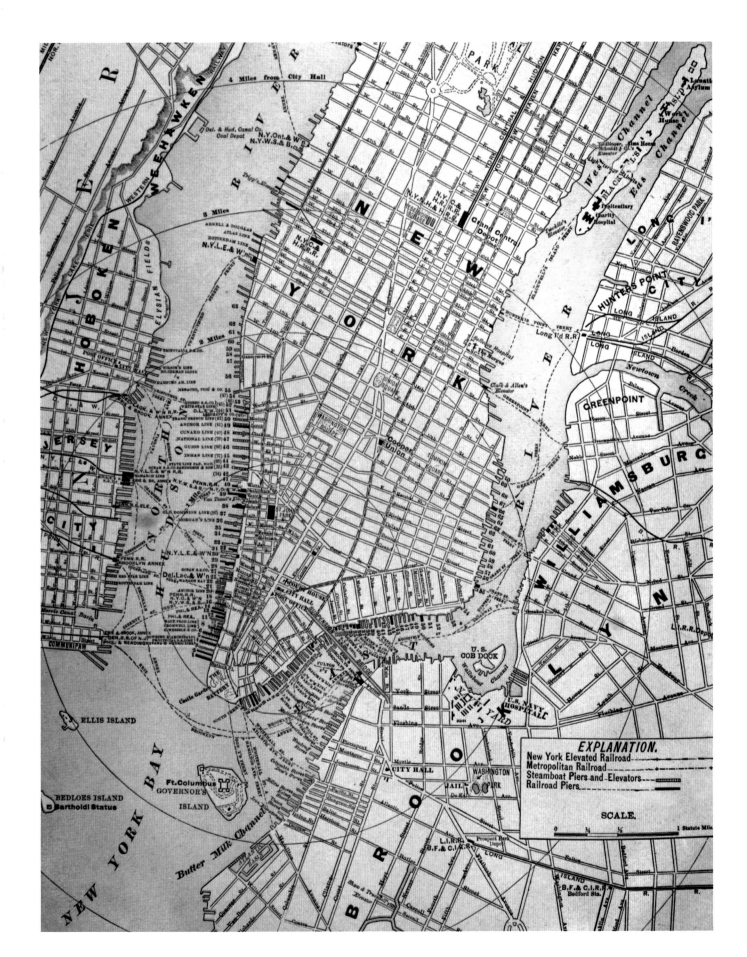

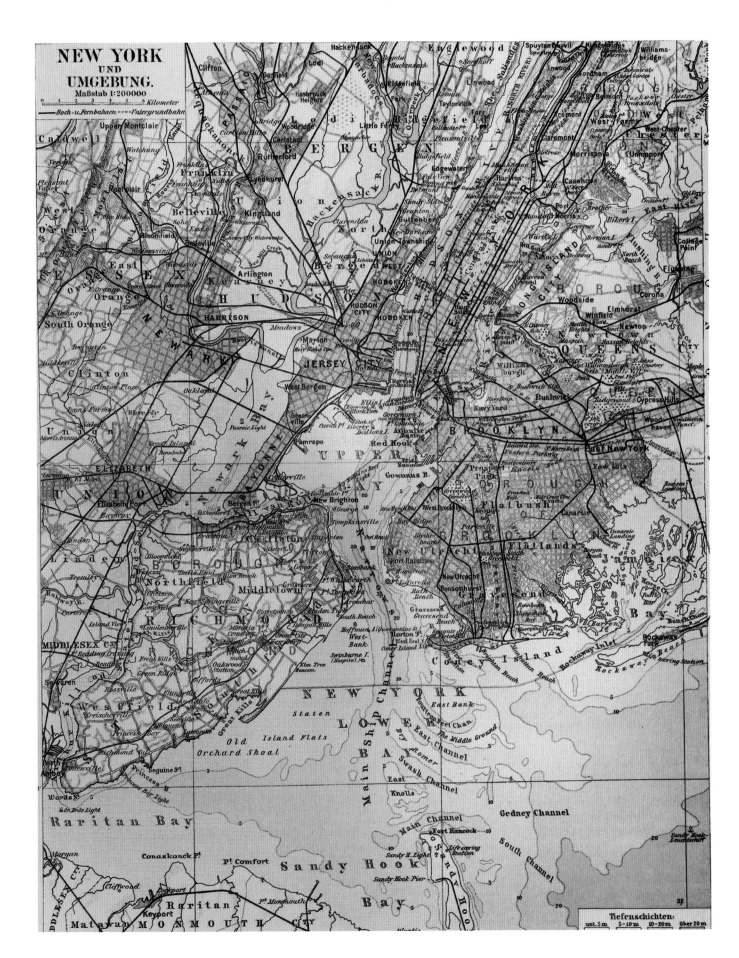

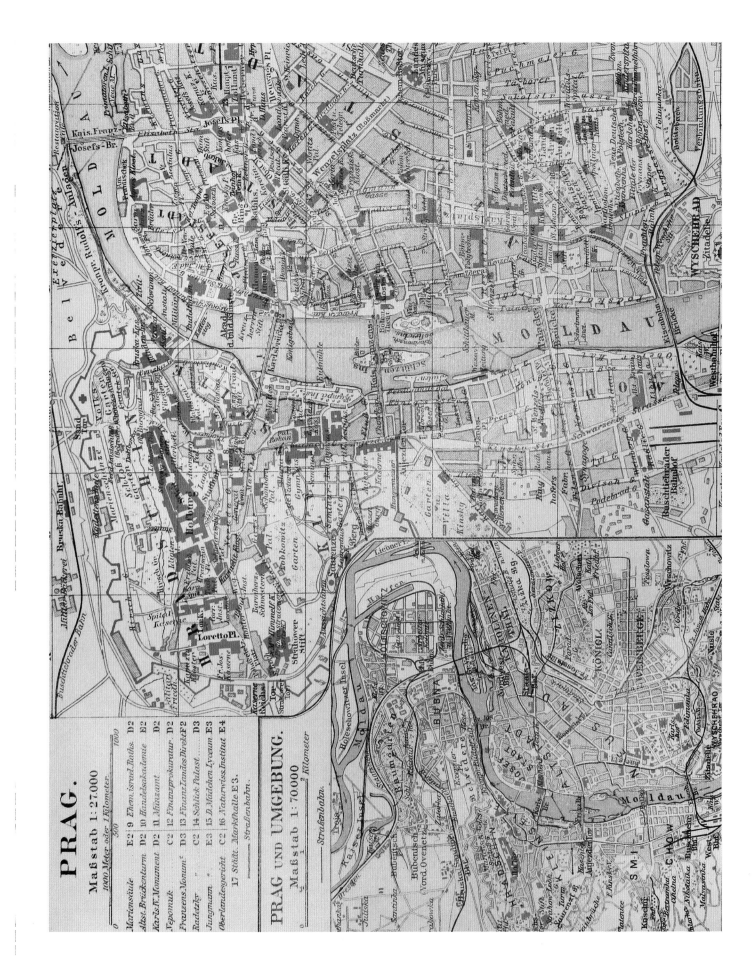

PRAG.

Maßstab 1:27000

1000 Meter oder 1 Kilometer

500 1000

PRAG UND UMGEBUNG.

Maßstab 1:70000

0 1 2 Kilometer

Straßenbahn.

KOPENHAGEN.

ORESUND

AMAGER

Christianshavns
Felled

Maßstab 1:21500

Zum Artikel „Kopenhagen".

Bibliographisches Institut in Leipzig

Trekroner

Ingmenga

Revshalar

CHRISTIANSHAVN

KALVEBOD STRAND

SONDERBRO

FREDERIKSBERG

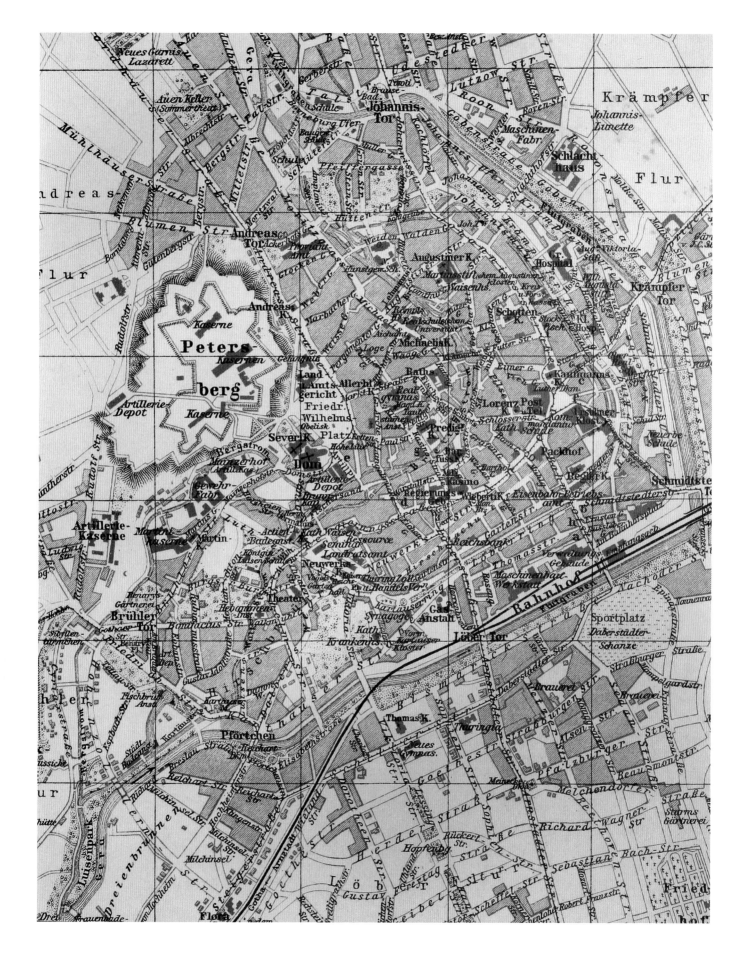

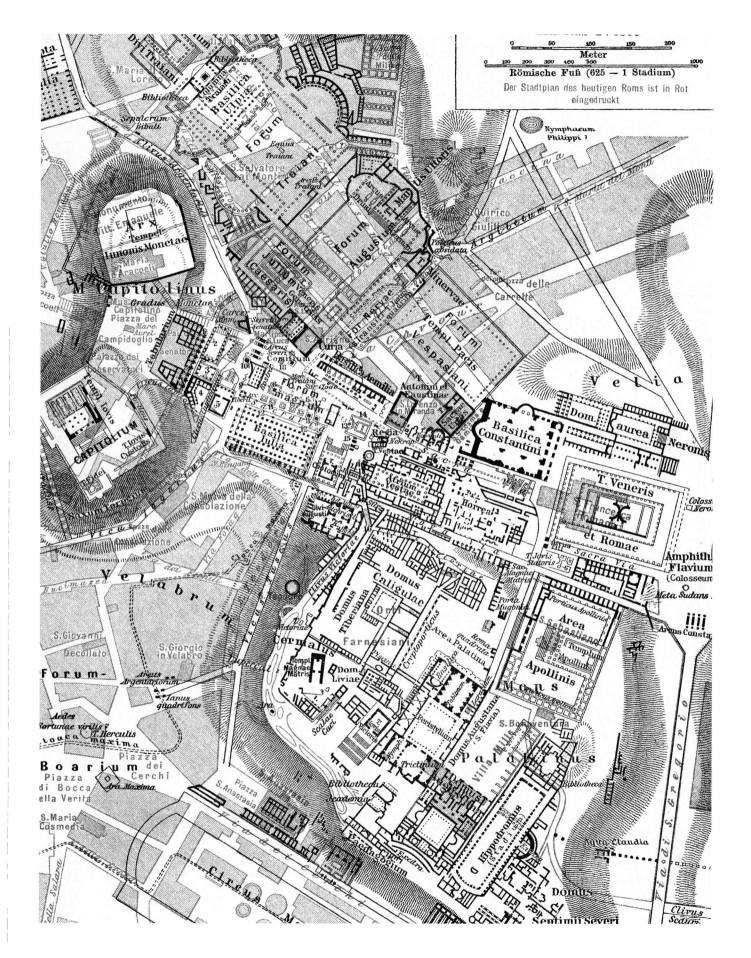

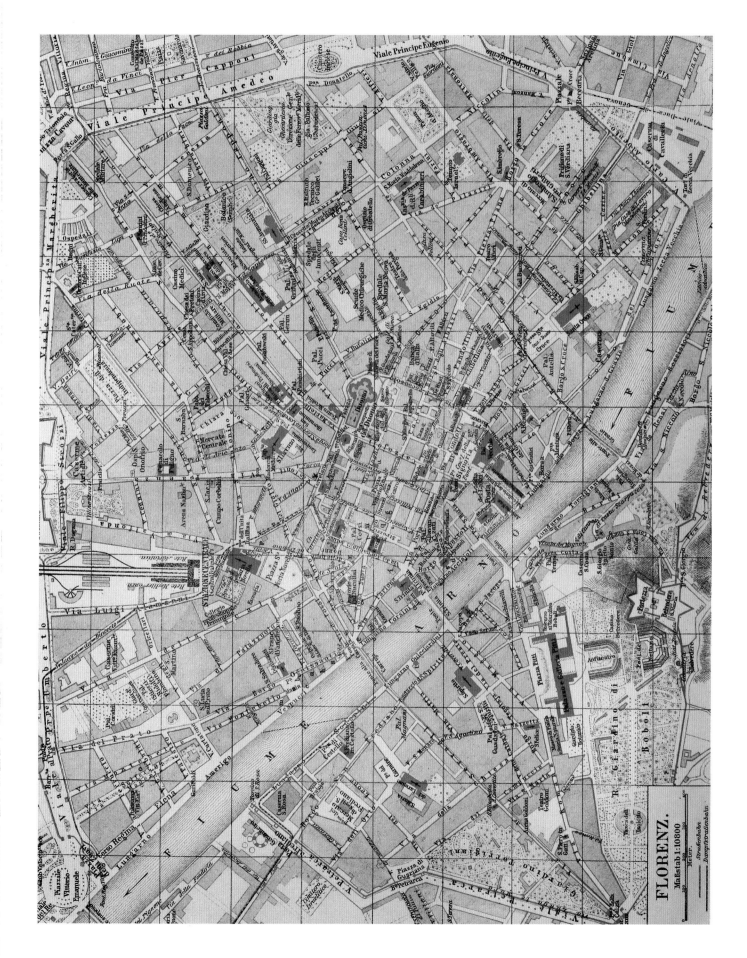

FLORENZ.

Maßstab 1:10800

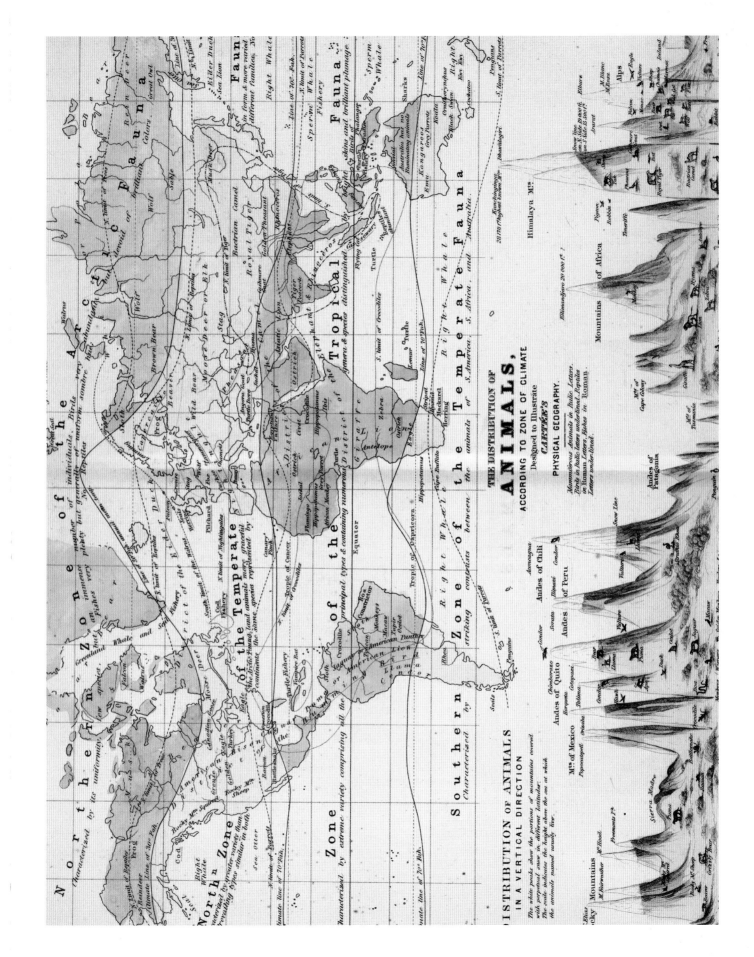

THE DISTRIBUTION OF ANIMALS,

ACCORDING TO ZONE OF CLIMATE

Designed to illustrate

CARTER'S

PHYSICAL GEOGRAPHY.

Mammiferous Animals in Italic Letters.
Birds in Italic letters underlined. Reptiles
in Roman Letters. Fishes in Roman
Letters underlined.

DISTRIBUTION OF ANIMALS

IN A VERTICAL DIRECTION

The white peaks show the portions of mountains covered
with perpetual snow in different latitudes.
The scale indicates the height above the sea at which
the animals named usually live.

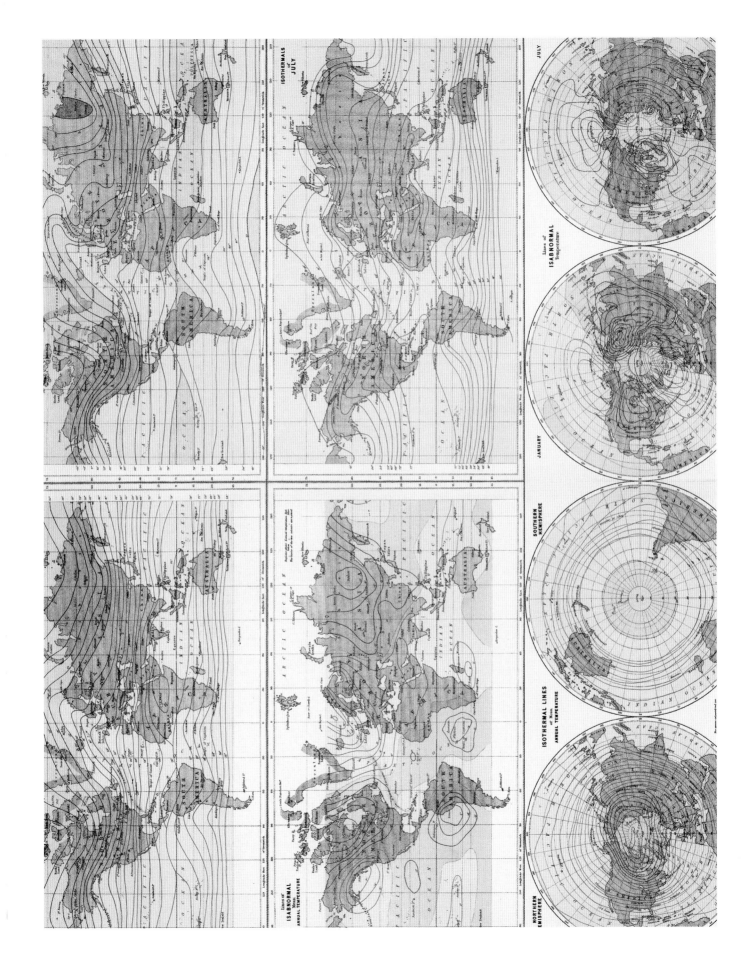

Lines of
ISABNORMAL
Mean
ANNUAL TEMPERATURE

ISOTHERMALS
of
JULY

Lines of
ISABNORMAL
Temperature

JULY

JANUARY

SOUTHERN
HEMISPHERE

ISOTHERMAL LINES
of Mean
ANNUAL TEMPERATURE

NORTHERN
HEMISPHERE

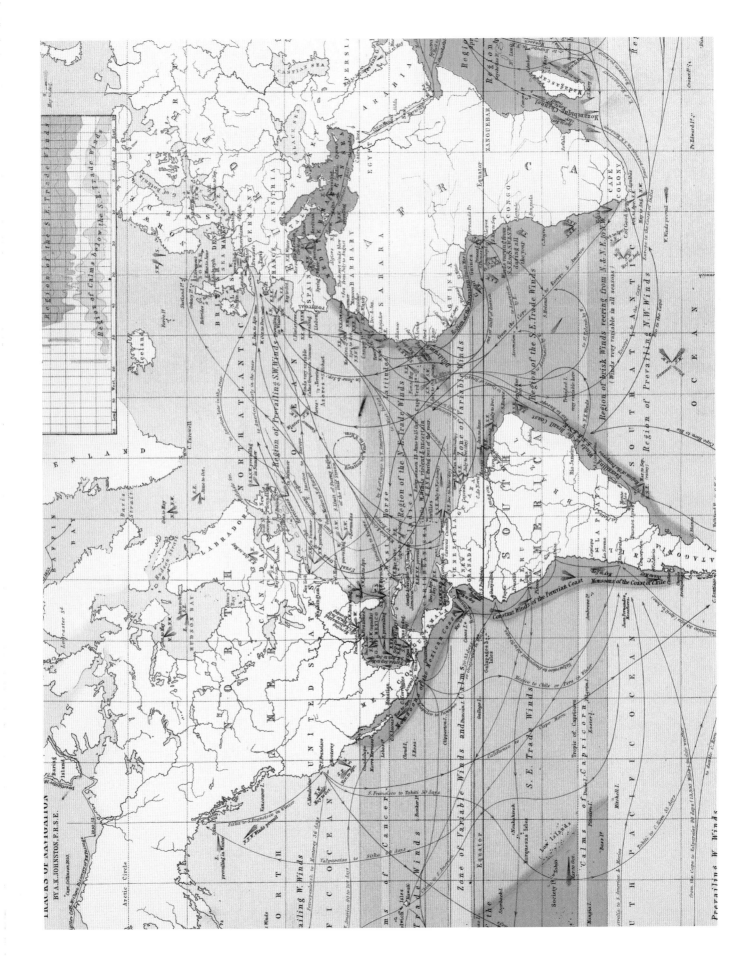

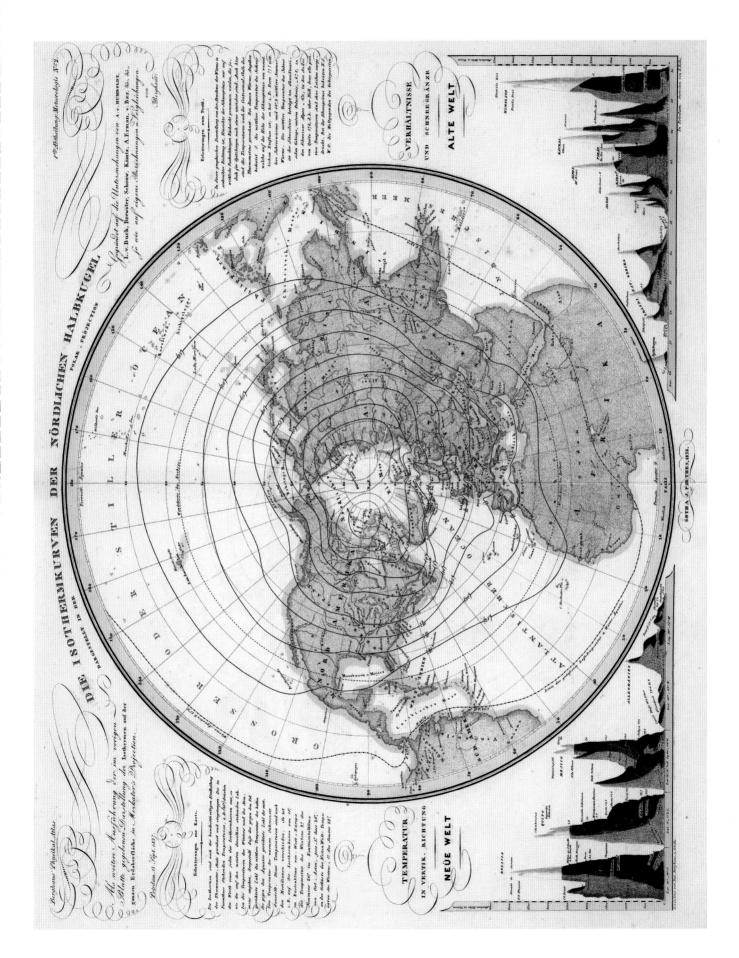

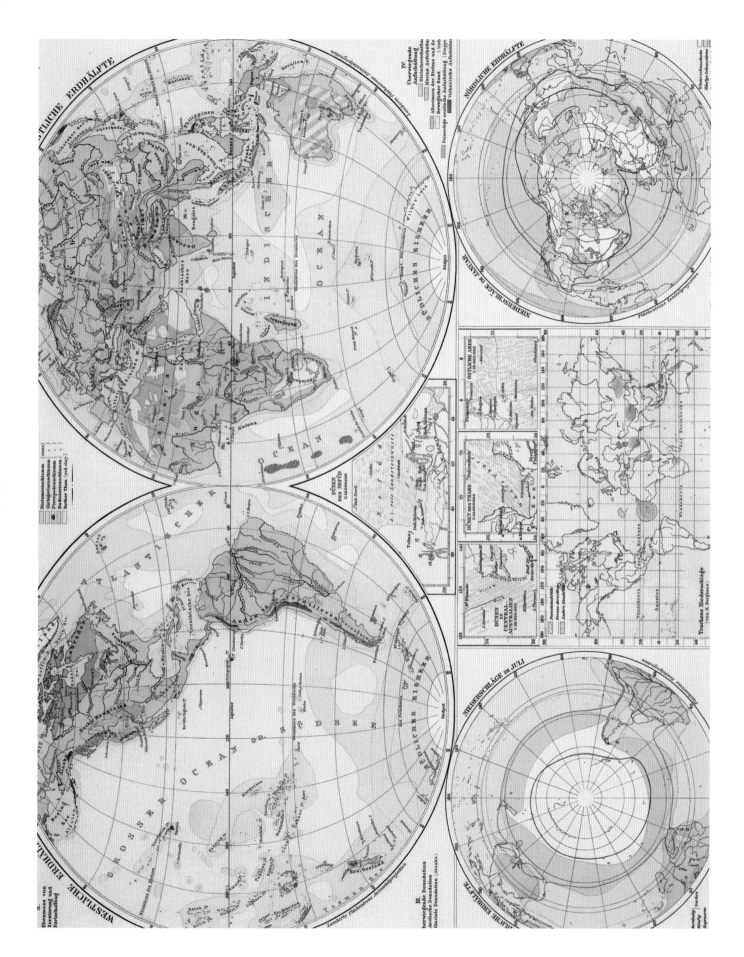

JAEHRES-ISOTHERMEN.

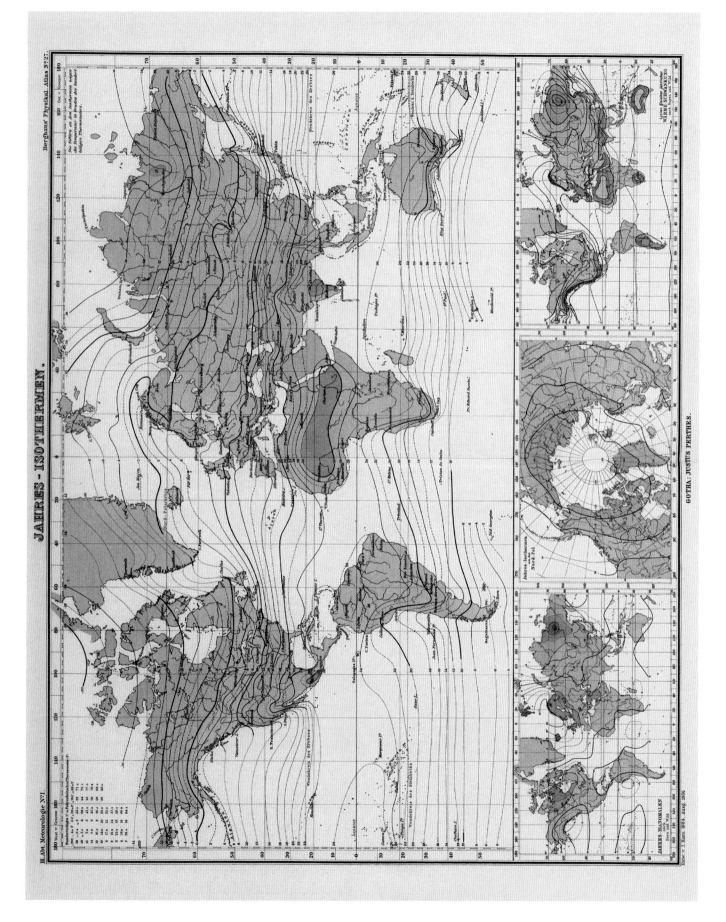

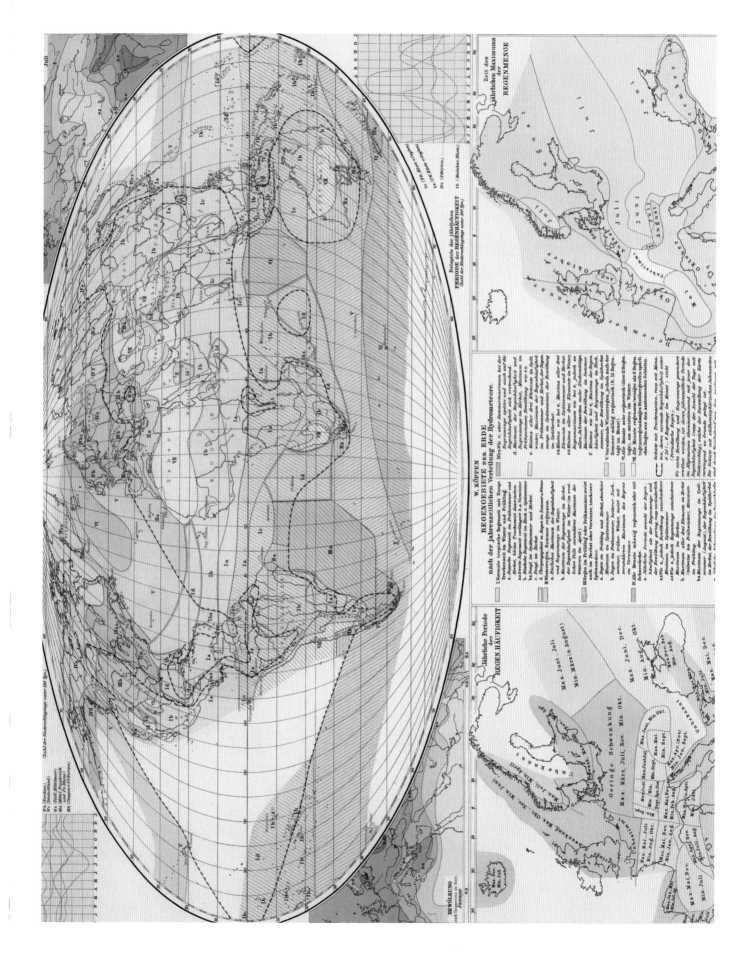

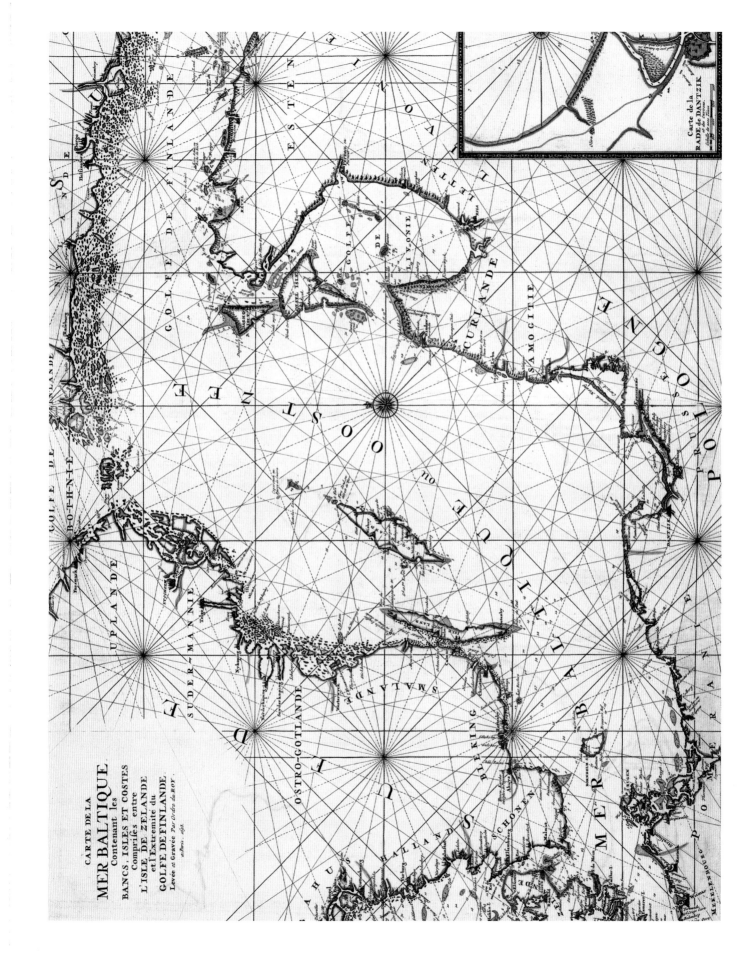

CARTE DE LA
MER BALTIQUE.
Contenant les
BANCS, ISLES ET COSTES
Comprises entre
L'ISLE DE ZELANDE
et l'Extremité du
GOLFE DE FINLANDE.
Levée et Gravée Par Ordre du ROY.
à Paris 1693.

Carte de la
RADE de DANTZIK

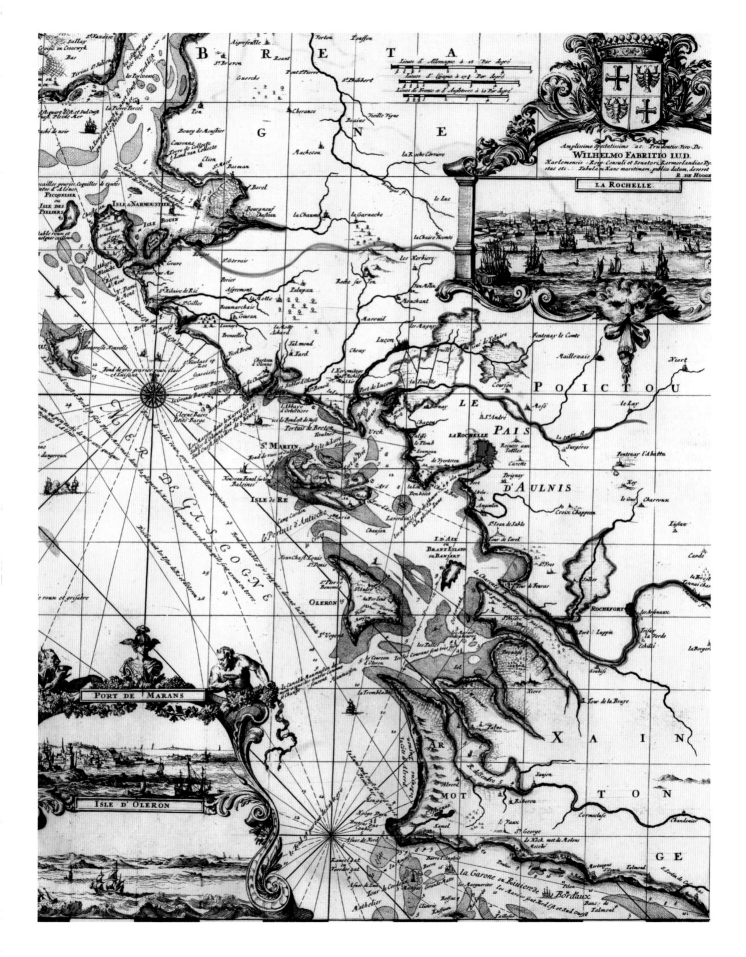

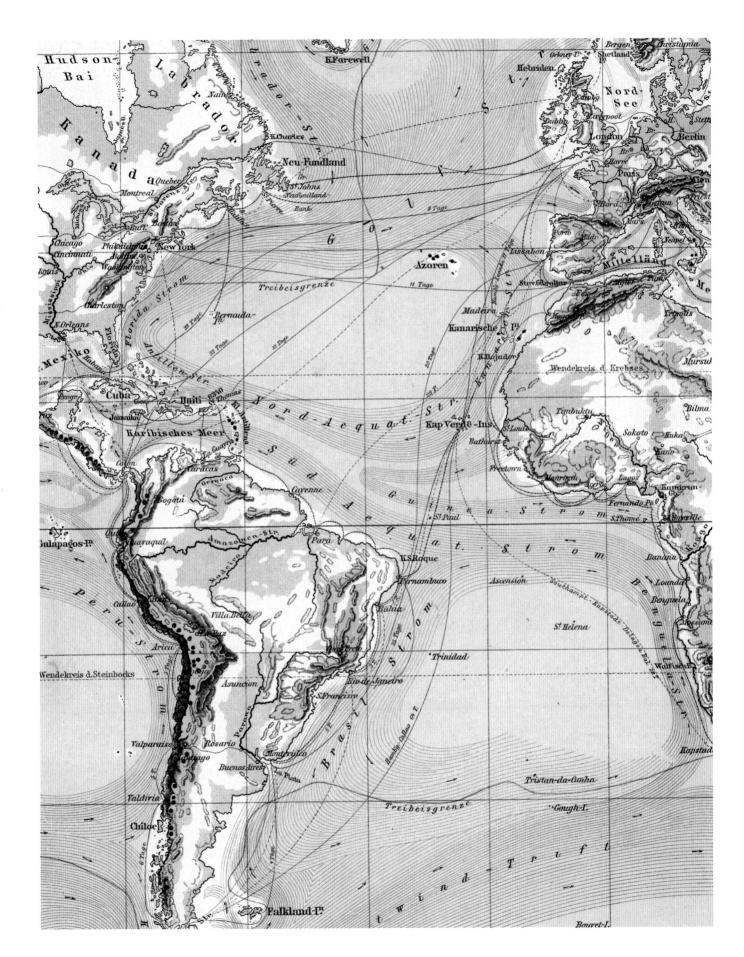

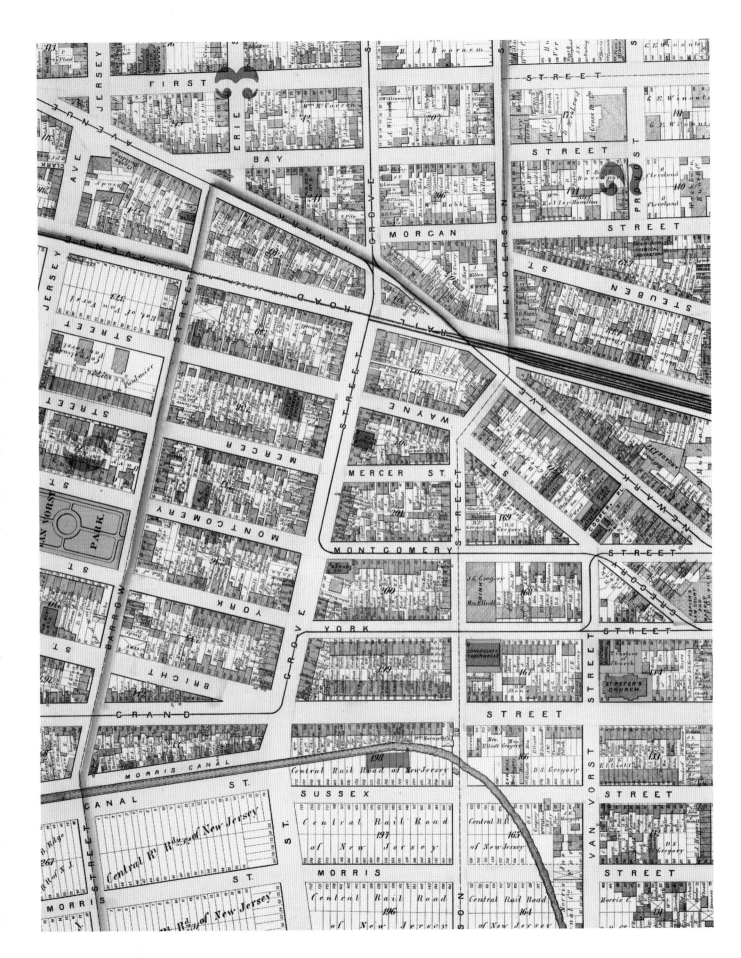

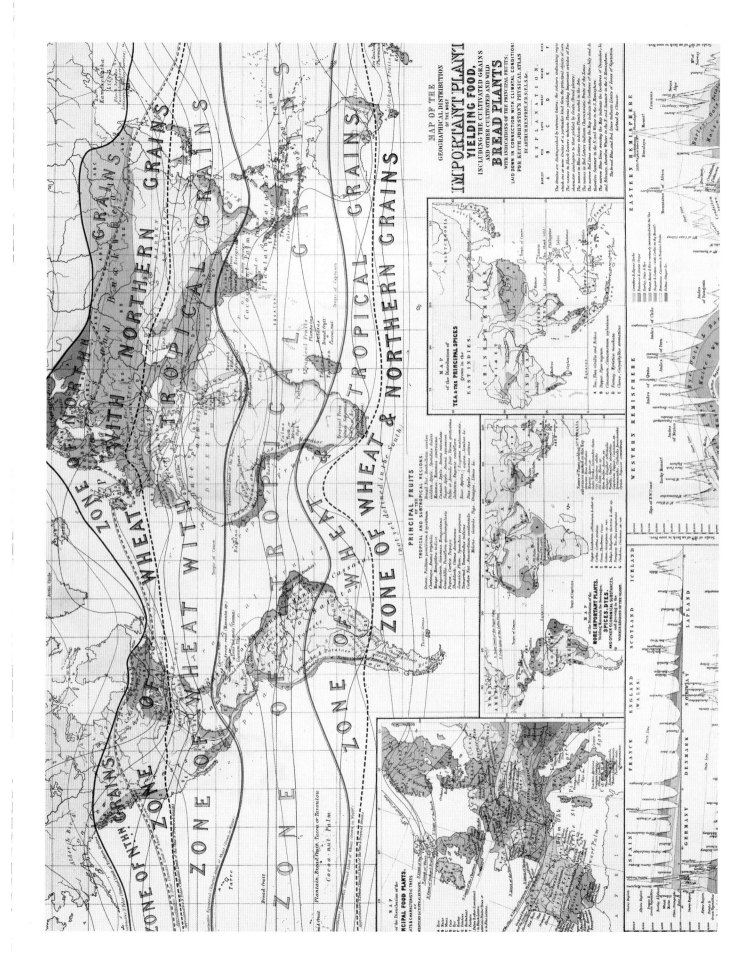

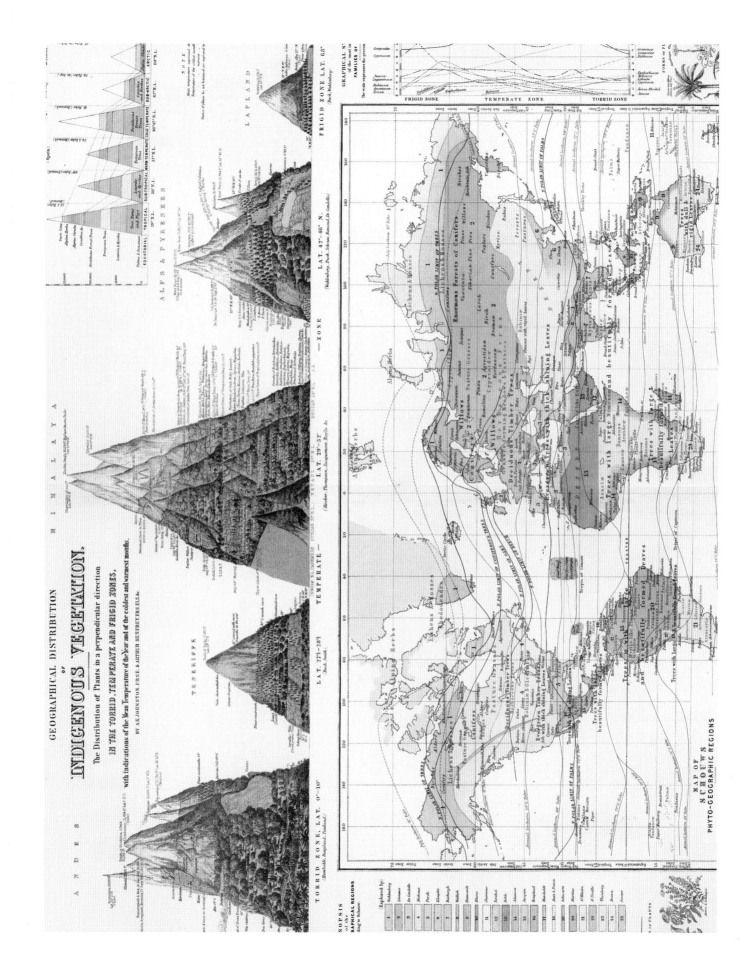

GEOGRAPHICAL DISTRIBUTION
OF
INDIGENOUS VEGETATION.

The Distribution of Plants in a perpendicular direction

IN THE TORRID, TEMPERATE AND FRIGID ZONES,

with indications of the Mean Temperature of the Year and of the coldest and warmest months.

BY A.K.JOHNSTON, F.R.S.E. & ARTHUR BESFREYER, F.L.S.&c.

MAP OF SCHOUWS
PHYTO-GEOGRAPHIC REGIONS

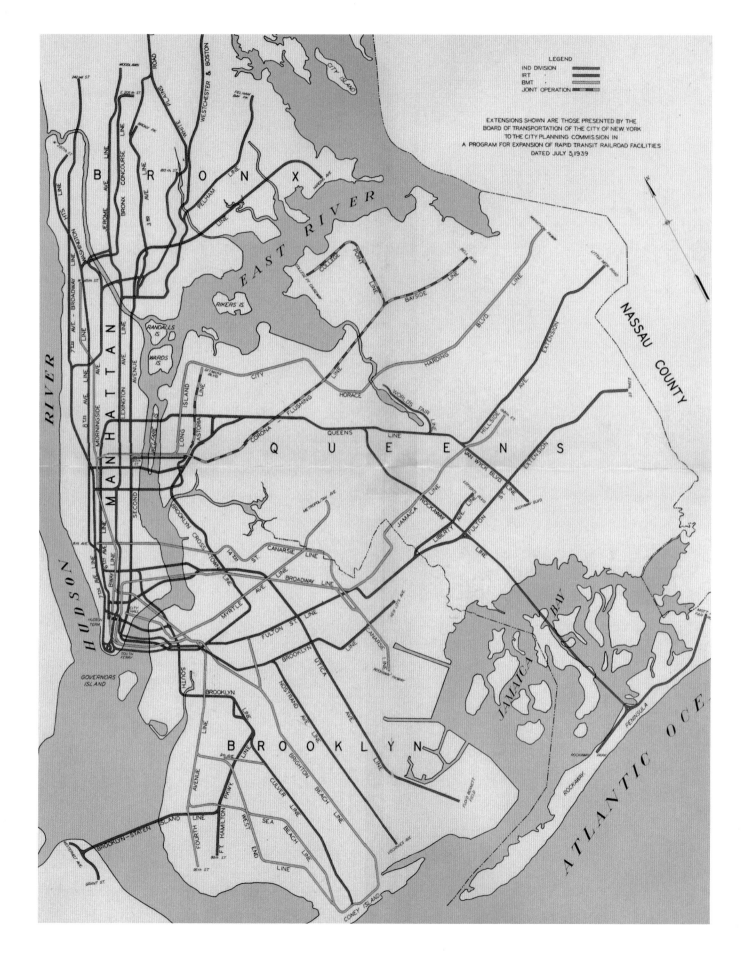

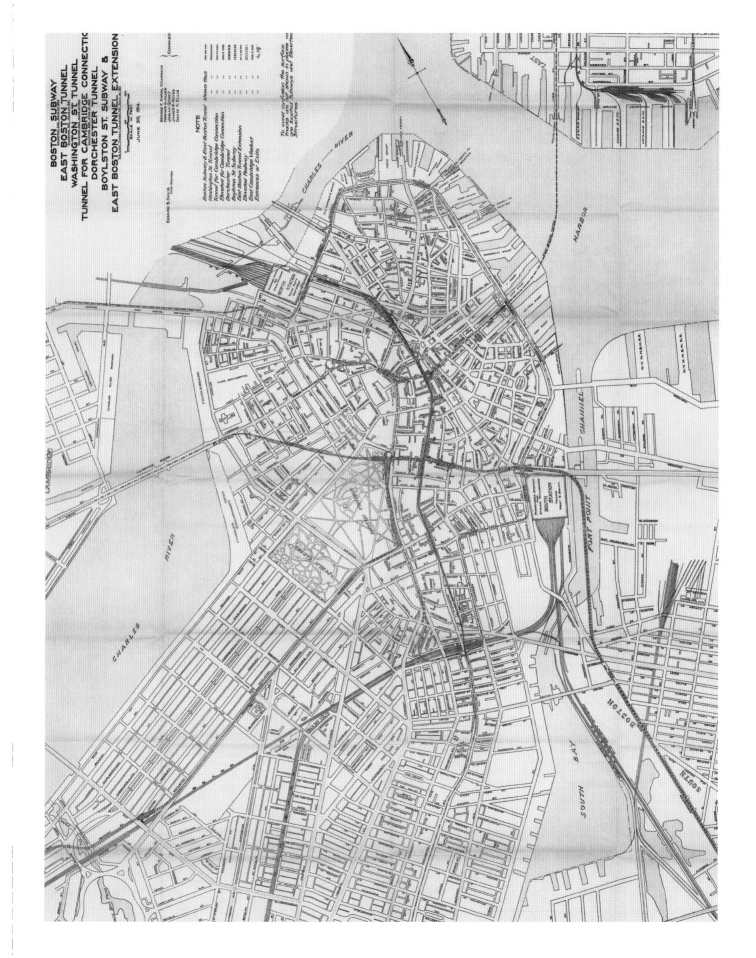

BOSTON SUBWAY
EAST BOSTON TUNNEL
WASHINGTON ST. TUNNEL
TUNNEL FOR CAMBRIDGE CONNECTION
DORCHESTER TUNNEL
BOYLSTON ST. SUBWAY &
EAST BOSTON TUNNEL EXTENSION

JUNE 30, 1914.

SCALE IN FEET

GEORGE F. SWAIN, CHAIRMAN
HORACE G. ALLEN
JOSIAH QUINCY
JAMES R. NOYES
DAVID A. ELLIS } COMMISSI

EDMUND S. DAVIS, CHIEF ENGINEER

NOTE

Boston Subway & East Boston Tunnel
Washington St. Tunnel
Tunnel for Cambridge Connection
Elevated for Cambridge Connection
Dorchester Tunnel
Boylston St. Subway
East Boston Tunnel Extension
Elevated Railway
East Cambridge Viaduct
Entrances or Exits

To avoid confusion the surface
tracks are not shown in places
are located Subways and Elevated
Structures

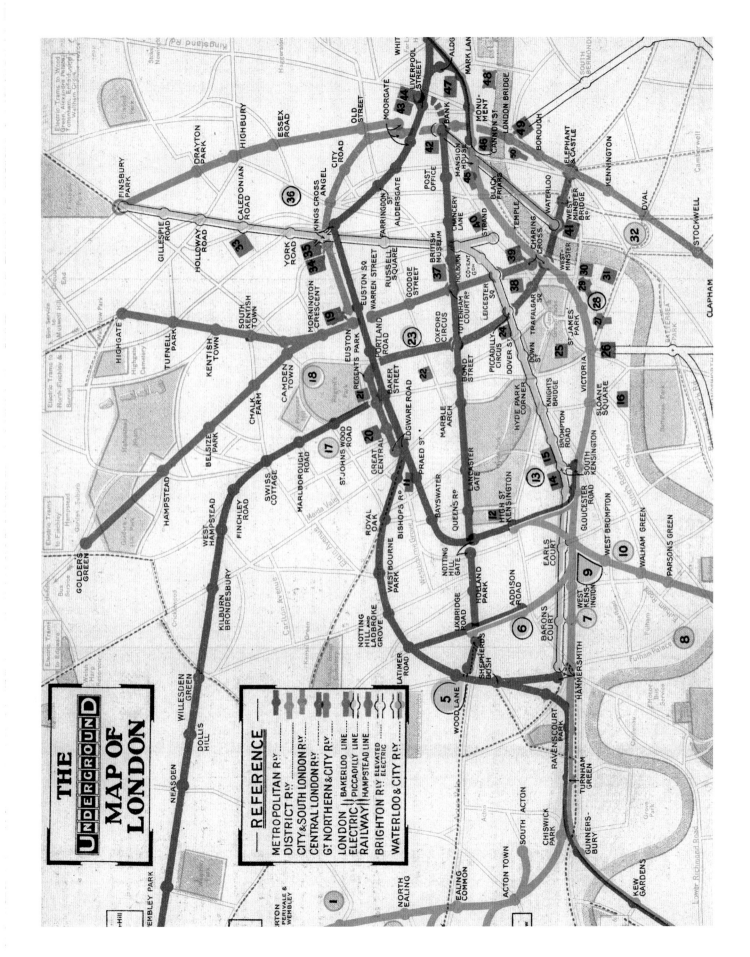

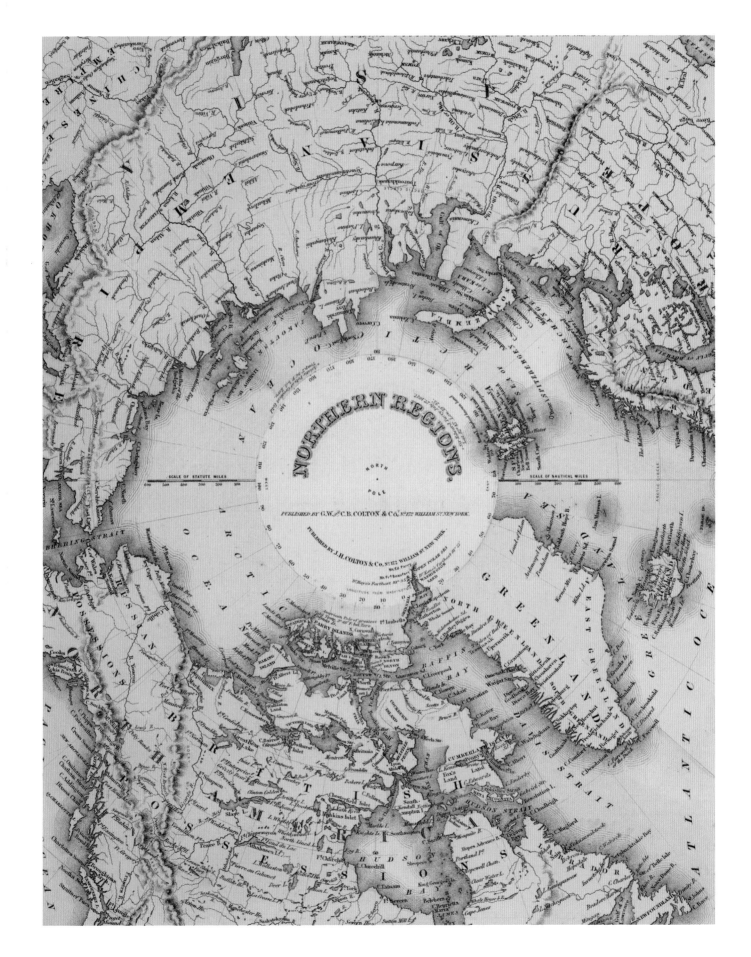

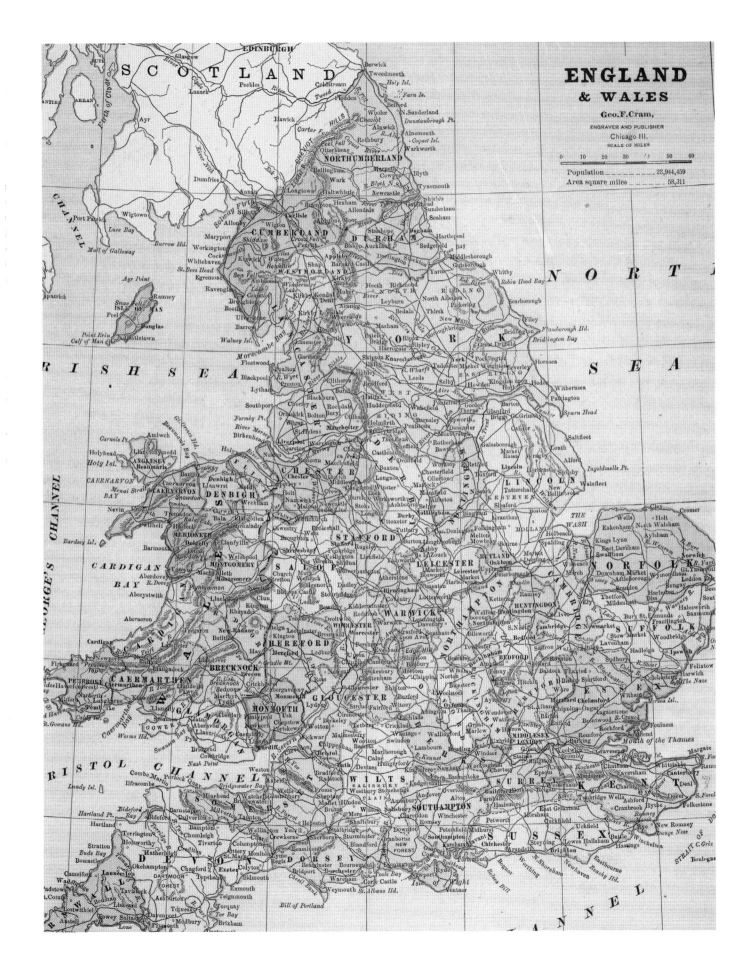

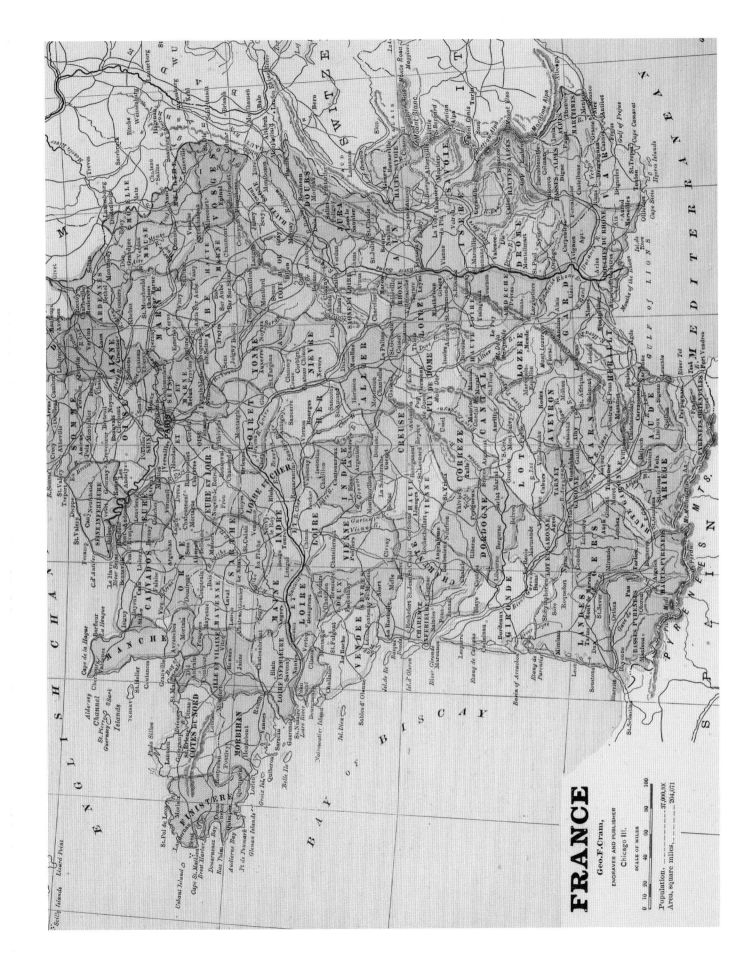

FRANCE

Geo. F. Cram,

ENGRAVER AND PUBLISHER

Chicago Ill.

SCALE OF MILES

0 10 20 40 60 80 100

Population, - - - - - 37,000,000
Area, square miles, - - - 204,071

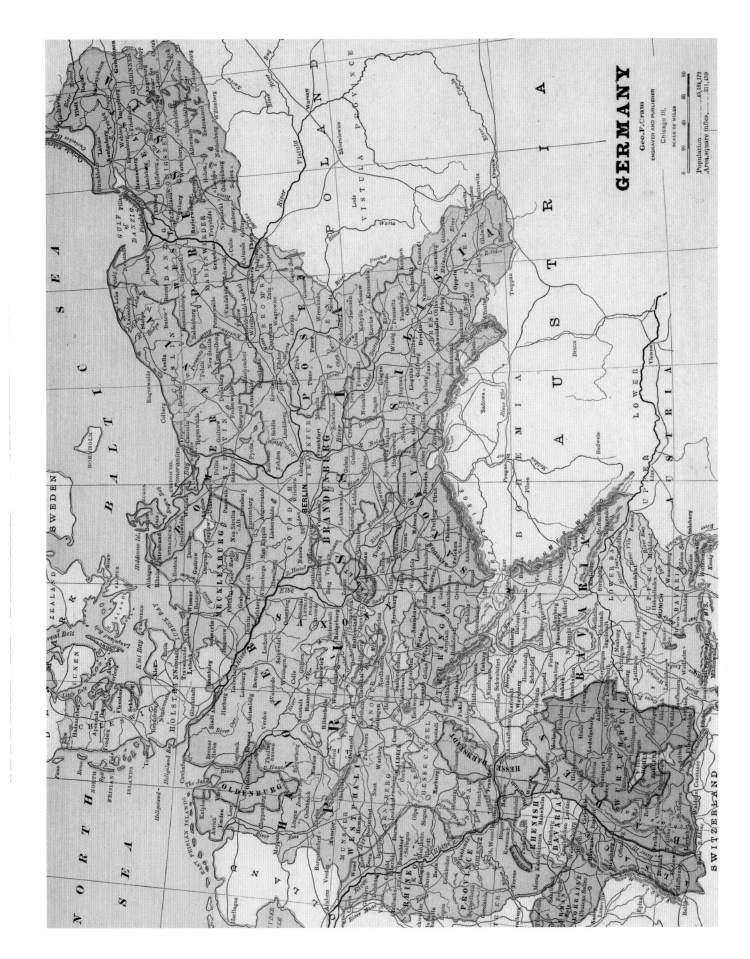

GERMANY

Geo.F.Cram

ENGRAVER AND PUBLISHER

Chicago Ill.

SCALE OF MILES

Population 46,194,173
Area square miles 211,459

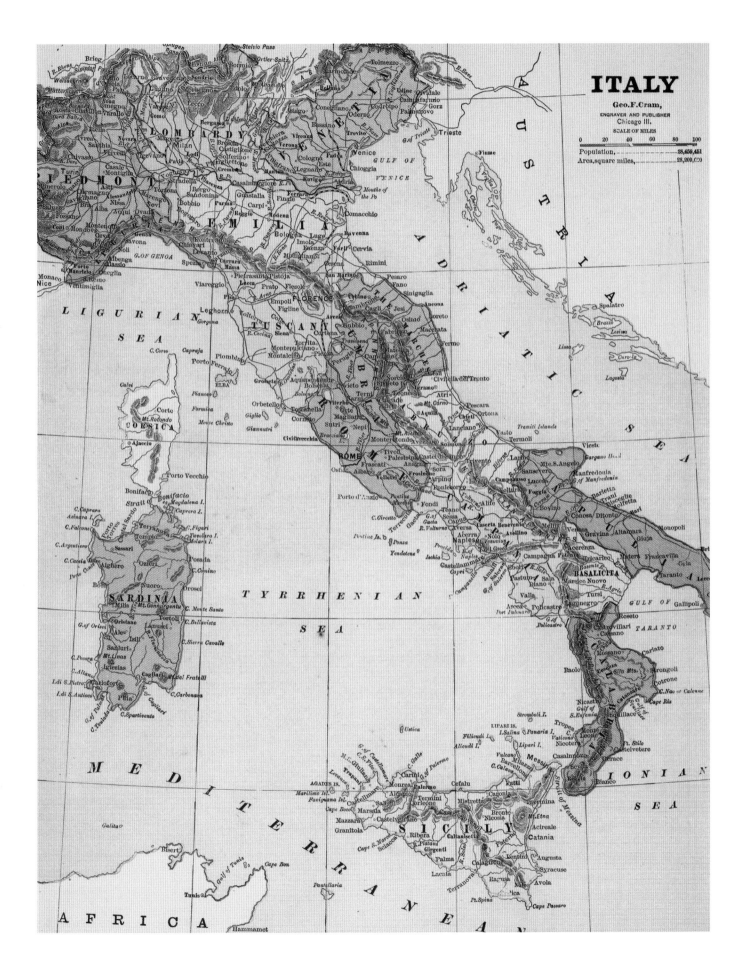

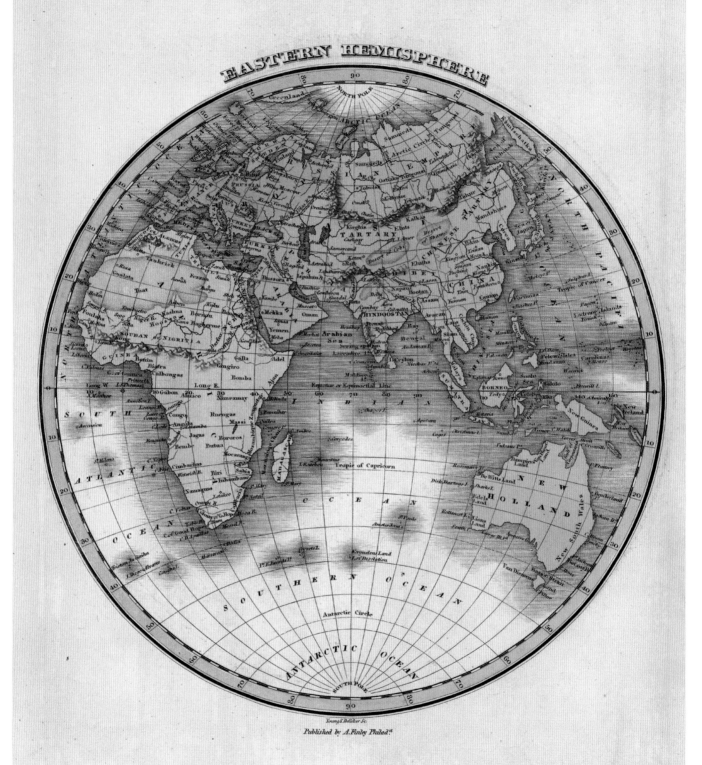

EASTERN HEMISPHERE

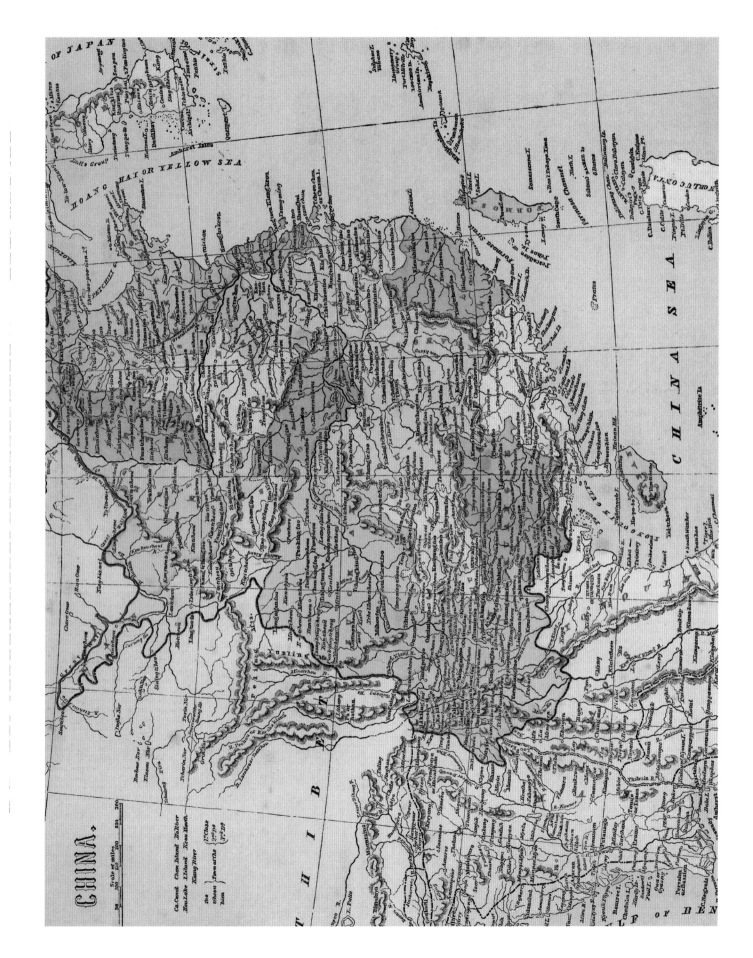

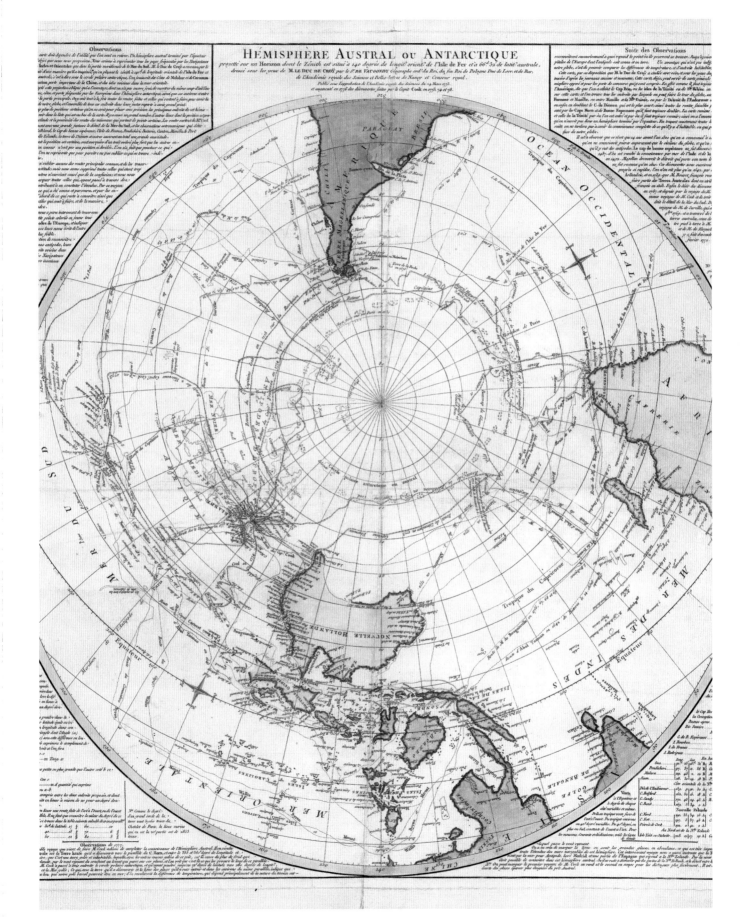

HÉMISPHÈRE AUSTRAL ou ANTARCTIQUE

projetté sur un Horizon dont le Zénith est situé à 140 degrés de longit. oriente de l'Isle de Fer et à 66d. 32' de latit. australe,
dressé sous les yeux de M. LE DUC DE CROŸ par le Sr. DE VAUGONDY Geographe ord. du Roi, du feu Roi de Pologne Duc de Lorr. et de Bar,
de l'Académie royale des Sciences et Belles-lettres de Nancy et Censeur royal.
Publié sous l'approbation de l'Académie royale des Sciences le 14 Mars 1773.
et augmenté en 1776 des découvertes faites par le Capit. Cook en 1773, 74 et 78.

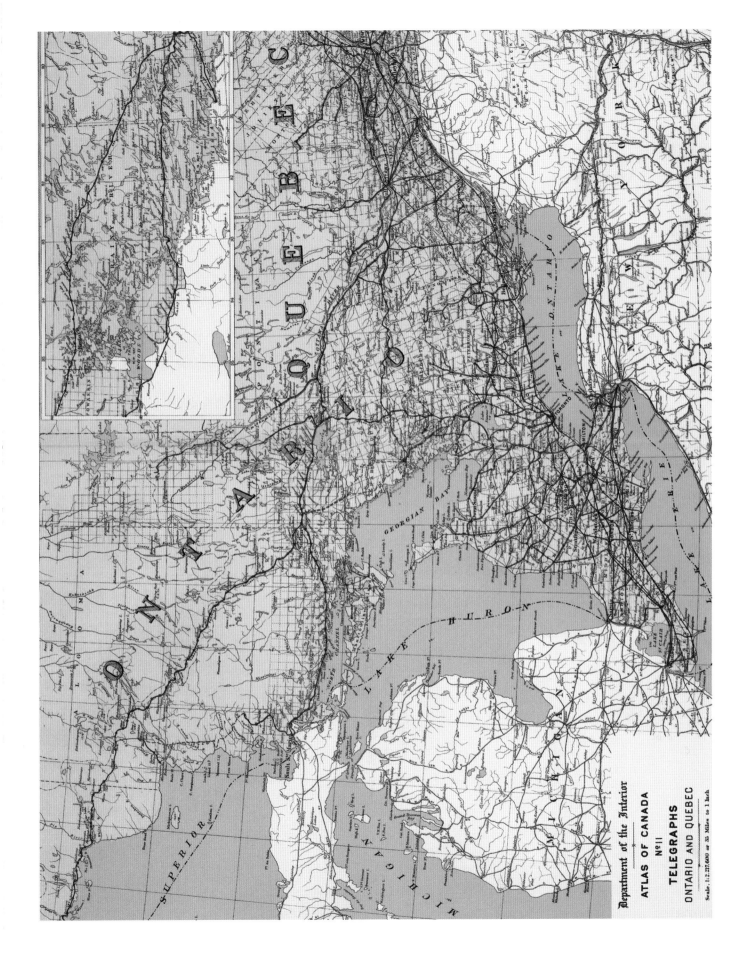

QUEBEC

ONTARIO

NEW YORK

LAKE ONTARIO

GEORGIAN BAY

LAKE HURON

LAKE ERIE

LAKE SUPERIOR

MICHIGAN

LAKE MICHIGAN

LAKE OF THE WOODS

ALBANY RIVER

Department of the Interior

ATLAS OF CANADA

Nº 11

TELEGRAPHS

ONTARIO AND QUEBEC

Scale. 1:2,217,600 or 35 Miles to 1 Inch

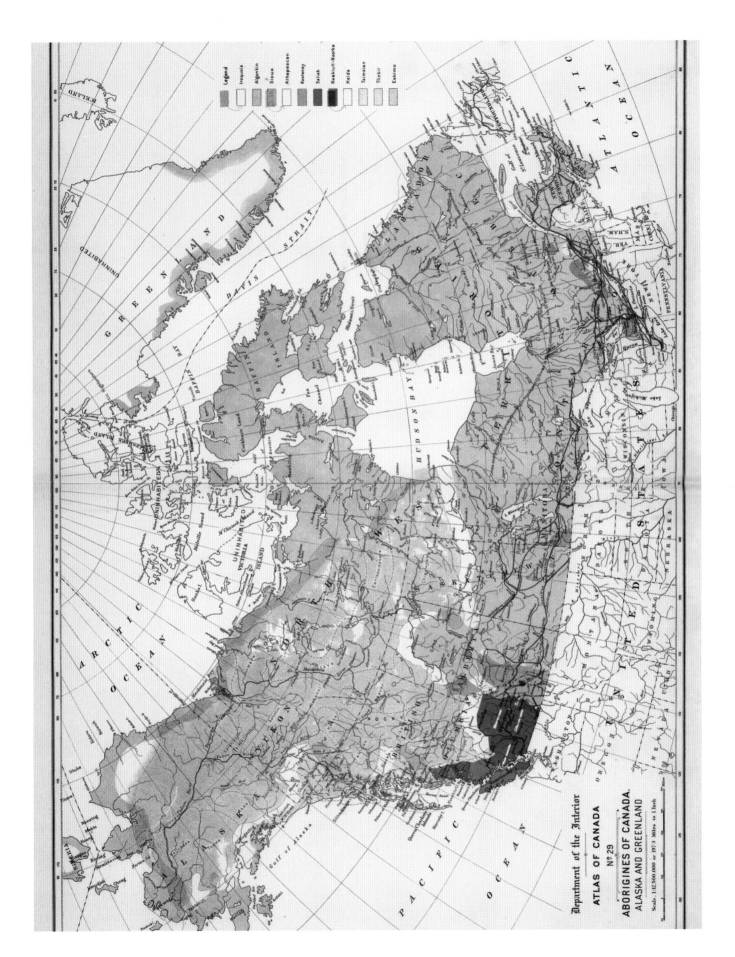

Department of the Interior

ATLAS OF CANADA
Nº 29

ABORIGINES OF CANADA,
ALASKA AND GREENLAND.

Scale: 1:12,500,000 or 197.3 Miles to 1 Inch

Legend

Iroquois
Algonkin
Sioux
Athapascan
Kootenay
Salish
Kwakiutl-Nootka
Haida
Tsimsian
Tlinkit
Eskimo

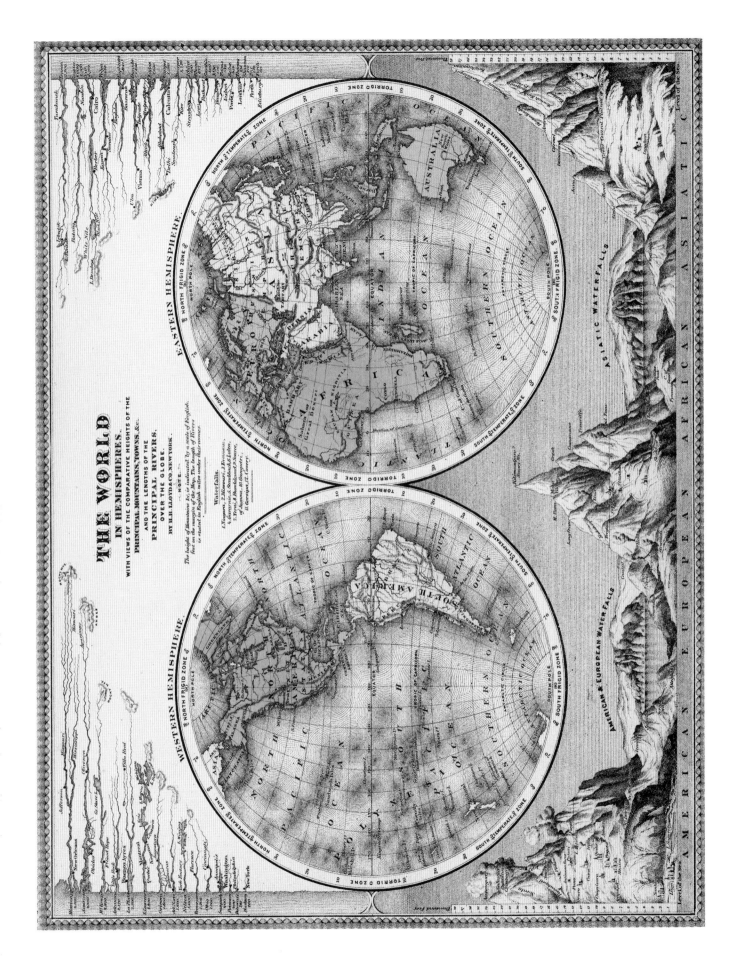

THE WORLD
IN HEMISPHERES.

WITH VIEWS OF THE COMPARATIVE HEIGHTS OF THE
PRINCIPAL MOUNTAINS, TOWNS, &c.
AND THE LENGTHS OF THE
PRINCIPAL RIVERS,
OVER THE GLOBE.

BY H. H. LLOYD & CO. NEW YORK.

NOTE.

The height of Mountains &c, is indicated by a scale of English
feet, on the margin of the Map. The length of Rivers
is stated in English miles under their names.

Waterfalls.

1. Niagara, 2. Missouri, 3. Potomac,
4. Gavarnie, 5. Staubbach, 6. Lutin,
7. Terni, 8. Bandelean, 9. Saane,
of Japura, 10. Ganpati,
11. Gairopit, 12. Clivery.

EASTERN HEMISPHERE.

WESTERN HEMISPHERE.

ASIATIC WATERFALLS

AMERICAN & EUROPEAN WATERFALLS

AMERICAN EUROPEAN AFRICAN ASIATIC

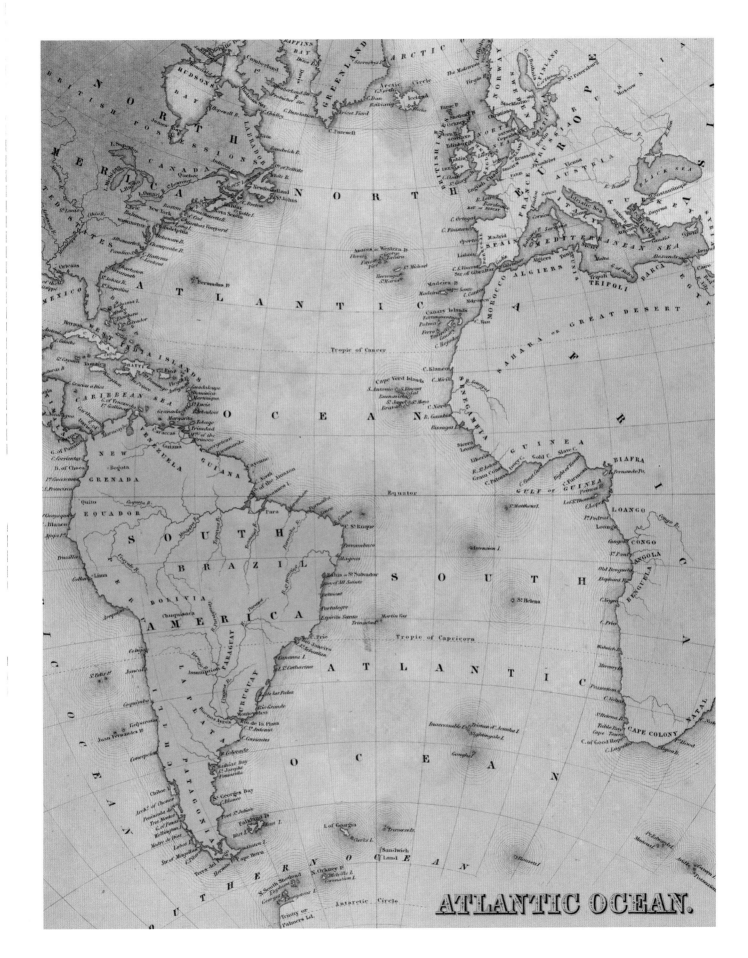

ATLANTIC OCEAN.

EUROPA.
Politische Übersicht.

Maßstab 1:25 000000.
Deutsche Meilen 15%.

Kilometer 111×1″.

Die Hauptstädte sind unterstrichen.

DER
NÖRDLICHE
STERN.HIMMEL
(Mitte des 19. Jahrhunderts).

STIELER'S HAND-ATLAS N° 5*

GOTHA : JUSTUS PERTHES
1874.

Lith. v. A. Stieler. Neue Aufl. berichtigt v. D? C. Bruhns.

DER NÖRDLICHE STERN-HIMMEL.

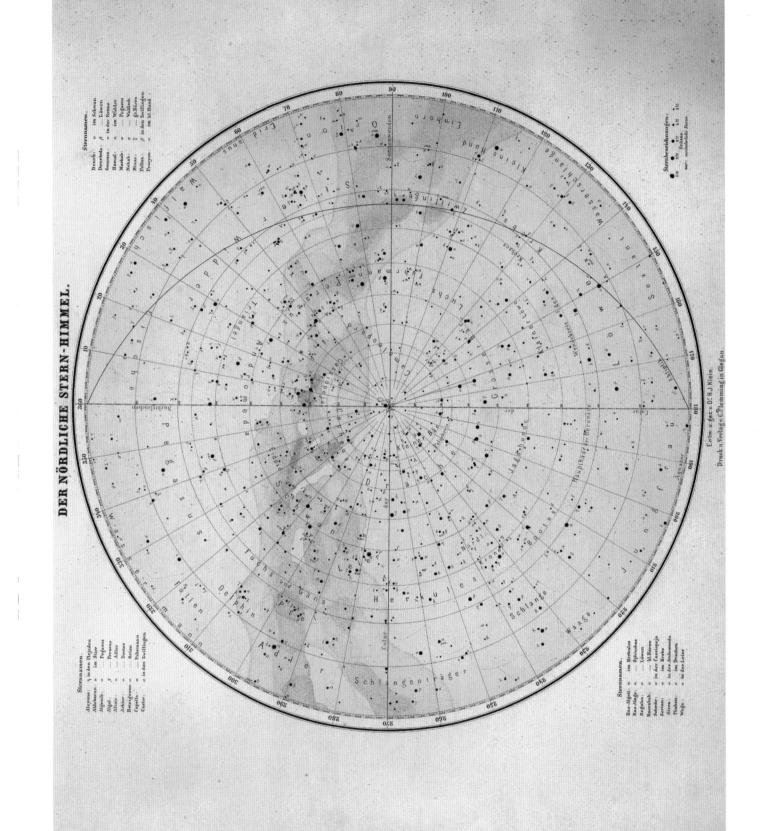

Sternnamen.

Alcyone: η in den Plejaden.
Aldebaran: α im Stier.
Algenib: α Pegasus.
Algol: β Perseus.
Altair: α Adler.
Arktur: α Bootes.
Beteigeuze: α Orion.
Capella: α Fuhrmann.
Castor: α in den Zwillingen.

Sternnamen.

Deneb: α im Schwan.
Denebola: β Löwen.
Gemma: α in der Krone.
Hamal: α im Widder.
Markab: α Pegasus.
Mekab: α Walfisch.
Mizar: ζ gr. Bären.
Pollux: β in den Zwillingen.
Procyon: α im kl. Hund.

Sternnamen.

Ras-Algeti: α im Herkules.
Ras-Alage: α Ophiuchus.
Regulus: α Löwen.
Rastanbah: α kl. Bären.
Schedir: α in der Cassiopeja.
Sertan: α im Krebs.
Sirrn: α in der Andromeda.
Thuban: α im Drachen.
Wega: α in der Leier.

Sternbezeichnungen:
1te 2te 3te 4te 5te Grösse.
ver. veränderliche Sterne.

Entw. u gez.v. D.r H.J. Klein.
Druck u.Verlag v. C.Flemming in Glogau.